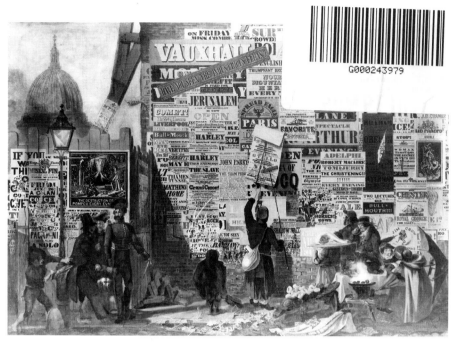

Technical developments in the printing industry in the early nineteenth century brought a radically new appearance to street advertising, as is well exemplified in this painting of 1835 by John Parry. Although Parry has somewhat exaggerated their scale, the posters well convey the brash new typography of the period.

THE VICTORIAN PRINTER

Graham Hudson

Shire Publications Ltd

CONTENTS

Published in 1996 by Shire Publications Ltd, Cromwell House, Church Street, Princes Risborough, Buckinghamshire HP27 9AA, UK. Copyright © 1996 by Graham Hudson. First published 1996. Shire Album 329. ISBN 0 7478 0330 7. Graham Hudson is hereby identified as the author of this work in accordance with Section 77 of the Copyright, Designs and Patents Act 1988.

Printed in Great Britain by CIT Printing Services, Press Buildings, Merlins Bridge, Haverfordwest, Pembrokeshire SA61 1XF.

British Library Cataloguing in Publication Data. A catalogue record for this book is available from the British Library. Hudson, Graham, 1937- The Victorian Printer. – (Shire album; no. 329) 1. Printing industry – Great Britain – History – 19th century 2. Printed ephemera – Great Britain I. Title 686.2'0941 ISBN 0 7478 0330 7.

ACKNOWLEDGEMENTS

For help and advice during the preparation of this book I wish to thank: Dr Pierre Lapierre, Kent Institute of Art and Design; Keith Parker, Assistant Curator (Communications) at the Science Museum, London; Amoret Tanner; Stewart Thirkell, Administrator, Cherryburn; Professor Michael Twyman BA, PhD, FCSD, FIOP. Photographs are acknowledged as follows: Beamish, The North of England Open Air Museum, cover; Alfred Dunhill Collection, page l; St Bride Printing Library, pages 4,7 (shaded and Tuscan), l0 (barge); National Trust, Cherryburn, page 9 (lower); National Trust for Scotland, page 3l. The illustration on page 5 is based on the Stanhope press in the Science Museum, London. The photograph by the author of the Vesta Tilley bill on page 8 is from an original in the collection of Leeds City Libraries.

Cover: *A printer working the 1837 Columbian press in the reconstructed print shop at Beamish, the North of England Open Air Museum, County Durham.*

Below: *Printer's billheading, 1835. Cutbush was equipped to print by each of the three processes but that this is letterpress work is evidenced by the characteristic horizontal stress of the typography. Cutbush has set his name in the style of type known as Italian, introduced in 1821. Decorative type ornaments and an (unauthorised) royal arms add richness to the design. Composition would have entailed fitting together around nine hundred separate pieces of type metal.*

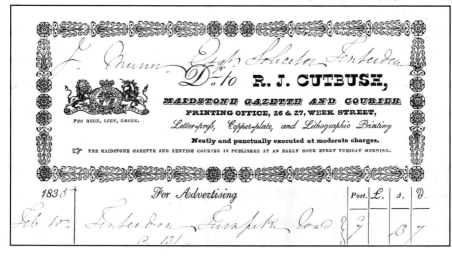

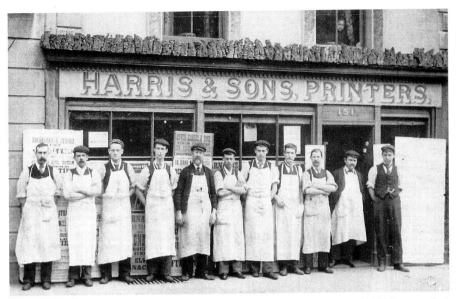

Edwin Harris of Rochester, Kent, poses between sons and journeymen in this 1899 photograph. A young woman gazes down from the domestic quarters above. Between the figures one glimpses typical jobbing work printed on the firm's hand presses and powered machines.

INTRODUCTION

Printing has a long history, the Koreans having printed from hand-cut wood blocks as early as the eighth century AD. Woodblock printing appeared in Europe in the fourteenth century and was used in the production of material as diverse as playing-cards and devotional prints. Printing entailed no more than dabbing the block with ink, laying paper over it, then rubbing with a burnisher, whilst lettering cut in the block was fixed and thus not adaptable for any other job.

Major advances came with the work of Johann Gutenberg of Mainz in Germany, who in the 1440s invented the printing press and type mould, the latter enabling large numbers of individual letters – printer's type – to be cast from a single set of matrices. Spreading across Europe, this technology was well established by the time that William Caxton, the first English printer, set up his press at Westminster in 1476.

Also dating from the fifteenth century was printing from engraved metal plates, a process wholly different from letterpress printing and chiefly employed for pictorial work.

For nearly three and a half centuries there were only minor developments, printing continuing as essentially a craft-based activity. Even to Gutenberg and his contemporaries a printing office of 1800 would have been quickly familiar. But all was to change over the next hundred years as the carpenter-built wooden printing press gave way to the iron press, which in turn was succeeded by platen and cylinder machines, whilst engraving was supplanted by the new process of lithography.

Book, newspaper and jobbing printing were to develop as virtually separate trades, and it is with jobbing work that this book is chiefly concerned. In appearance, and in the widening scope of what was printed, things were to change radically, with new typefaces, formats and approaches to design arising in response to the commercial and cultural changes of the new century.

3

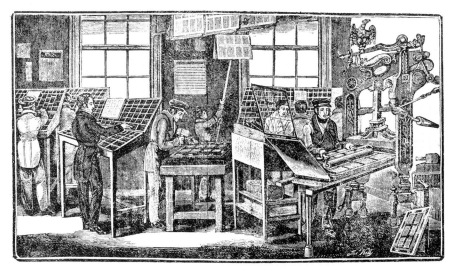

A printing office c.1830. On the left compositors set type whilst in the centre another 'comps' locks pages of type into an iron chase to make up a forme. On the right a pressman inks up a forme ready for printing. The press is a Columbian, manufactured in England from 1817, one of the powerful iron hand presses which helped revolutionise printing in the early nineteenth century.

LETTERPRESS PRINTING

Letterpress printing – printing from type and other relief imagery – is akin to making a fingerprint. Ink adheres only to the raised surfaces and is not picked up by the lower areas between. Printing is effected by bringing the inked surfaces into firm contact with paper.

A single piece of type is a square-section column of lead alloy approximately 23 mm (⅞ inch) high with a letter or other character cast in reverse on its top surface. A wide variety of type was available to the printer, in face sizes ranging from less than 2 mm (¹⁄₁₆ inch) to a massive 50 mm (2 inches). Larger sizes than this were usually made of wood.

Type was set by a compositor, who had before him two cases divided into the various compartments needed for the many different letters, figures, punctuation marks and spaces that setting called for. Following handwritten copy, the 'comps'

first set the type letter by letter in a *composing stick* adjusted to the length of line required. When all copy had been 'through the stick', the type and any illustration blocks were firmly locked into an iron *chase*, the whole then constituting the printing *forme* which was passed on to the pressmen.

The printing press at the beginning of the nineteenth century was still much as it had been when invented in the fifteenth. The press was of wood and printing was effected by pulling on a bar acting directly on a screw. Greater pressure could have been achieved by lengthening the bar but the increased thrust would have burst the construction asunder. Development came around 1800 with the iron press invented by Lord Stanhope. The key to Stanhope's invention was compound levers which considerably magnified the force acting on the pressure plate or *platen*,

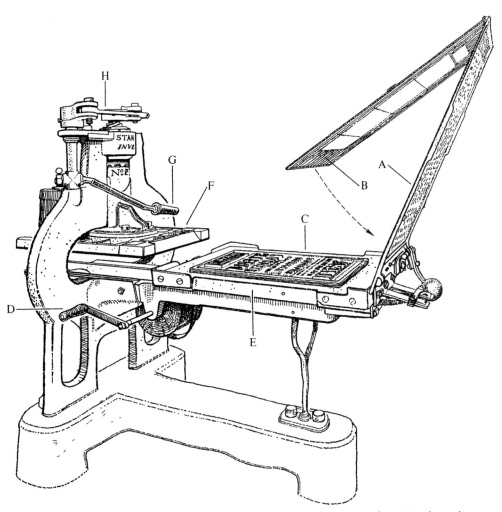

Stanhope iron press. The pressman placed the sheet of paper to be printed on the parchment-covered 'tympan' (A), then brought down the 'frisket' (B) to protect all but the area of paper that was to receive the impression. Meanwhile his partner inked the forme of type (C). Tympan and frisket with the paper sandwiched between were then swung down on to the forme and, using handle (D), the 'bed' (E) was run forward under the 'platen' (F). Pulling on the impression bar (G), the pressman then brought the platen down on to the tympan, thus effecting the transference of ink to paper. Key features of the Stanhope were the compound levers (H), which greatly magnified the force imparted by the bar.

thus enabling a larger sheet to be printed. In 1813 a rival iron press was invented by George Clymer of Philadelphia, who set up business in London in 1817. Clymer's press also used levers, which acted on a massive beam and piston to force down the platen. This press was the Columbian. Its most characteristic features were ex-travagant decoration and the American-eagle counterweight which rose and fell with every impression. Equal in power though more modest in appearance was Richard Cope's Albion press of c.1820. Instead of levers, the Albion had a steel toggle joint which the impression bar forced straight to create the downward

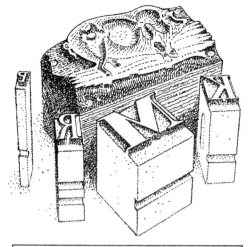

Stock block and various sizes of printer's type, and (inset) an adjustable composing stick with some lines of type already set.

thrust. Numerous other presses were to be designed in both Britain and the United States, all having in common iron construction and the use of mechanical advantage to increase the power of the pressman's arm.

During the eighteenth century there had been significant growth in provincial towns. Printing expanded out of London and by 1800 virtually every market town had its own printer. There was plenty for him to do: sale notices, prospectuses, stationery, guide books, playbills, the local newspaper. But, in addition, the printer could also sell writing paper, pens and books, even tea, cheeses and medicines, and in some cases as easily take a booking for a coach

Below: *Race bill, 1825, the main display line demonstrating the power of bold Egyptian type. The incised Roman of 'FIRST DAY' is a late eighteenth-century survival, whilst the decorated shaded fat face of 'GOLD CUP' was introduced by founders Blake, Garnett in 1819. The vigorous wood-engraved stock block was probably cut by a pupil of Thomas Bewick.*

YARMOUTH RACES.
FIRST DAY,
TUESDAY, the 16th of AUGUST, 1825.

A GOLD CUP

Value EIGHTY SOVEREIGNS, by Subscriptions of Ten Sovereigns each, with Twenty Sovereigns added by the Committee.—*Two-Mile Heats and Distance.*

MR. RUMBOLD, names ch. h. by Selim, out of Acquilina, 4-years old, 8st. 4lbs.—*Sky Blue* (CLIFF)
COL. WILSON's b. c. by Interpreter, out of Spotless, 4-years old, 8st. 4lbs.—*Green, Red & Black Cap* (SYER)
COL. THE HON. G. ANSON, SIR JACOB ASTLEY, BART., THOMAS CAY, ESQ., were Subscribers, but did not name.

SWEEPSTAKES of 20 GUINEAS each.
For 3-years old (H. F.)—*Mile Heats.*

SIR EDMUND BACON's Miss Shandy, 3-years old, 8st. 4lbs.—*Purple and White Cap.*

UNITED
HAMLET
FIGGINS
HANDEL
GARDEN

Some of the new styles of type introduced in the early nineteenth century: (from the top) fat face, Egyptian, Tuscan (a particularly decorative version of 1815), shaded, grotesque or sanserif.

or theatre seat as print a handbill.

Throughout the eighteenth century the Roman typeface (in essence the style of type in which this book is set) was virtually the only one that was available, and it was used to print everything from sermons to playbills. But the iron press made radical changes possible. A tendency towards increasing contrast between the thick and thin strokes of the Roman letter culminated around 1809 in the first true *fat face* type, where the vertical strokes were enormously fattened and the horizontals and serifs (the 'ticks' at the ends of strokes) reduced to hairlines.

Established conventions thus broken, the way was open for increasing inventiveness in type design to meet the needs of the quickening commerce of the new century. In 1815 came the first of the *shaded* faces, introduced by the typefounder Vincent Figgins, and the first *Tuscan* with its forked and curling strokes. Also in 1815 *Egyptians* were introduced, with uprights, horizontals and even serifs taking a slab form, creating some of the strongest, blackest faces ever to be designed. Later came *sanserifs* or *grotesques*, the letters without serifs, which in countless variations were to play their part in typography through the Victorian period and beyond. Rival founders cut their own versions of each, with italic, condensed and expanded variations, and a host of decorative types defying easy classification. It was the new presses that made such developments possible, for the greatly increased inking area occasioned by a dense setting in Egyptian or fat face demanded a printing pressure of which only an iron press was capable.

A new style of layout developed in

7

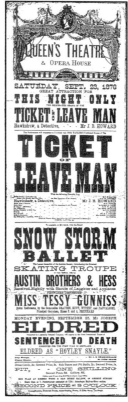
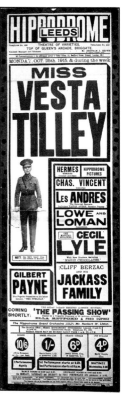

1789 1830

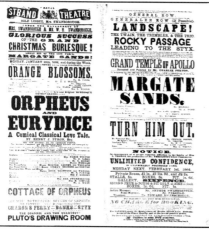

1864 1876 1914

Playbills, 1789 to 1914, showing increasing size and changes in typography and format. The conservatism of the eighteenth-century bill set in Roman type is readily apparent. The 1830 example achieves its strong display with attention-demanding Egyptian and fat-face types, whilst that of 1864 is a double playbill designed for folding across for easy perusal in a crowded theatre. The 1876 bill is headed by a title block engraved in wood by J. Fraser, whilst that of 1915 is illustrated with a pasted-on halftone. The latter bill is 880 mm overall depth.

which printers set the key words of posters and notices in type that could not be ignored. With the gist of the copy thus readable at a glance, the passer-by was induced to stop and so take in the rest. A form of poster to be produced in tens of thousands through the century was the long-format playbill, which had a dual function, for though its bold typography enabled it to speak loudly as a poster, the majority were sold to the audience as programmes. Eighteenth-century bills were small and of conventional proportions, but the iron press and cheap machine-made

paper led to increasing size. This in turn encouraged theatre managements' flights of fancy in copywriting, for playbills were designed to be read, not merely referred to. To have made the bill bigger all round would have rendered it awkward to read in the narrow confines of a theatre seat, hence the long narrow format. Double-playbill format was also used – a sheet of conventional proportions printed as two columns for folding down the centre.

The printing of illustrations from *wood engravings* was well established by 1800. The picture was cut into the surface of a

8

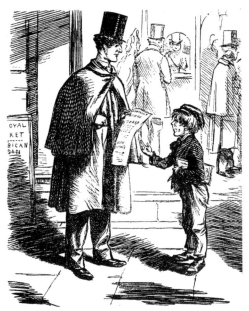

Wood engraving in the black-line technique, reproducing the pen strokes of the artist's original drawing on the wood. To the boy selling playbills the playgoer says: 'Two-pence? Oh, then I won't have a bill; I've only got a penny.' To which the lad replies: 'Then pray don't mention it, Sir. Never mind the hextra penny. I respects genteel poverty.' ('Punch', 1862.)

block of boxwood with a steel *burin*. In effect the engraver drew with white into what otherwise would have printed solid black. This was the white-line technique of Thomas Bewick, whose work had done much to popularise wood engraving from around 1770.

Bewick both conceived and cut his own designs, but increasing demand for illustration in the nineteenth century led to separation of the two stages, the artist drawing the image on the block in ink, then passing it on to an engraver, whose job was simply to cut away the wood between the lines. This created a facsimile pen drawing – the black-line technique.

In the 1820s stereotyping, a form of casting from plaster-of-Paris, was perfected, followed in the 1840s by electrotyping, processes by which replica blocks could be made. The latter was an electrochemical process whereby a copper skin was formed in a mould taken from the block and then made solid with type metal. Thereafter illustrations were mostly printed from stereos or electros rather than from the easily damaged wood. A further consequence was the proliferation of stock blocks, engravings of a generic nature of ships, trains, cattle, horses, the royal arms, etc, which a printer could use on similar jobs for different customers. When current events afforded opportunity

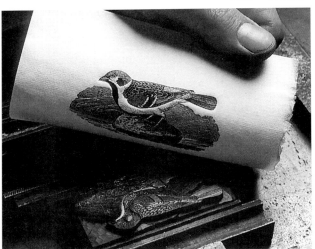

Wood block engraved by Thomas Bewick (1753-1828) and a modern proof taken from it. Although he is best-known for his natural-history illustrations (this is the mountain sparrow from the 'History of British Birds' of 1797) the greater part of the output from Bewick's workshop was wood and copper engravings for cards, billheads and other ephemera.

Printers' stock blocks. The canal scene is engraved in the white-line technique typical of the Bewick school and may well have been cut by one of Bewick's ex-apprentices.

typefounders also produced topical images, as in 1862 with the International Exhibition, or 1863 when portraits of the Prince of Wales and Princess Alexandra were available as stock blocks to celebrate the royal wedding.

The size of the printer's establishment could vary considerably. James Moyes's Temple Printing Office in London was erected in 1825 with accommodation for sixty compositors and forty or more pressmen; but firms could be very small, in London as well as in the provinces, perhaps comprising no more than the master and a journeyman. This was the minimum, for it took two men to work the press, one for the dirty job of inking and one to lay the paper and pull the impression.

At the beginning of the century the majority of letterpress printers were men of all work, as ready to print a book or a newspaper as a handbill. However, the mechanical developments of the period, the revolution in transport, the spread of literacy, the reduction and then in 1855 the abolition of the newspaper tax, all increased the variety and complexity of printed matter, and by around 1860 the trade had divided broadly into three: book printers, printers of newspapers, and the jobbing printers turning out the playbills, posters, leaflets, billheads and other ephemera so essential to commerce and society.

Billheadings of the 1840s showing the similarity in appearance between printing from a copper plate (top) and from a litho stone (bottom).

ENGRAVING AND LITHOGRAPHY

Letterpress was not the only means of printing: there was also printing from an engraved metal plate. The plate was a sheet of copper into which the engraver incised his design with a burin, the difference between this and the work of the wood engraver being that whereas the lines cut by the latter would be white when printed the lines of a copper engraving printed black.

The engraving of a plate was a separate trade from its printing, and only rarely were both carried out by the same business. Printing was a two-man activity. With the plate warmed over a charcoal stove the inker worked over the surface with a leather dabber, forcing ink into every engraved line. Then he cleaned it, first with a rag, then with the edge of his hand dusted with whiting, a skilled procedure resulting in a clean plate surface yet with ink remaining in all the engraved lines. Printing was done on a *rolling press* using dampened paper. The plate was laid on the bed, then the paper, with blanket over it. The whole was then wound

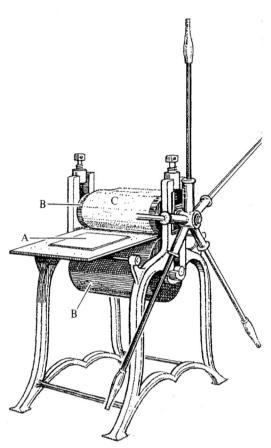

Rolling press for printing engravings: (A) plate resting on bed, (B) rollers, (C) blanket.

needle had exposed it, thus creating the recessed image through chemical action. Etched lines were freer than those of engraving and often both were combined on the same plate. A variation was *aquatint*, where resin dust was fused on the plate to form a partial acid resist, the result in printing being soft tonal qualities.

In the 1820s *steel engraving*, originally devised for printing banknotes, began to be more widely applied, at first in book illustration and then in more commercial work. The engraver worked in soft steel, which was then hardened. Steel better withstood the abrasion of inking and wiping, enabling long print runs of finely detailed imagery to be achieved.

In his day-to-day work an engraver was as likely to embellish a salver or race cup as engrave the plate for a tradesman's card. He therefore needed to be an artist of some ability. Thus these *intaglio* processes were employed wherever elegance was important and some increase in cost acceptable, as in invitations, bookplates, music covers and like items. The nature of letterpress composition, set line by line via a composing stick, imposed a sober regularity on layout difficult for the compositor to avoid; but the engraver was not similarly limited and, working on card or billhead, was free to create designs as elegant as artistry could achieve. A well-equipped printer might offer his customers printing by either letterpress or intaglio, but printed by letterpress the results would always be more workaday.

An image engraved in metal had permanence and little preparation was needed when further printing was ordered. However, if alterations to the design became necessary, as when a business partnership changed, the plate had to be hammered up from the back in the areas affected, then tediously burnished back to a smooth surface and re-engraved.

Printing an engraving took longer than letterpress work but this could be compensated for by multiple engraving, where virtually identical images were engraved on the same or additional plates, thus enabling several copies to be printed at

through the rollers, the pressure forcing the soft paper into the engraved lines, thus picking up the image. The action also produced a *plate mark*, the shape of the plate embossed into the paper. Regarded as unsightly, this could be reduced by drying the prints under pressure, but could not be wholly eradicated unless the nature of the job allowed it to be trimmed off all round.

Closely allied to engraving was *etching*, where the plate was coated with wax through which the design was drawn with a needle. The plate was subjected to acid, which ate into the copper wherever the

12

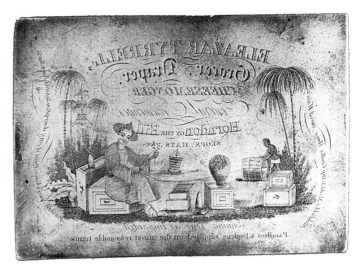

Copper plate for a tradesman's card, shown actual size, engraved by Reeves & Hoare, London, c.1820. The design is carried out in a combination of etching and engraving. The Chinaman, here holding a sprig of tea leaf, was a long established symbol of the tea trade.

each passage of the press. The procedure is to be distinguished from that employed in making the plates for the Penny Black postage stamps, where each intaglio image was struck from the one hardened-steel die: in multiple engraving each image was separately engraved by hand. The practice may have begun as late as the 1840s, when engravers were meeting increasing competition from lithography, otherwise known as 'printing from stone'.

In lithography the design was drawn on the plane surface of a slab of a special limestone using ink or crayon with high grease content. The stone absorbed the grease, making the image water-repellent. For printing, the stone was sponged with water, which was accepted only by the non-design areas, then rolled with ink, which, repelled by the damp stone, adhered only to the image. Paper was laid on and the stone taken through the press. The principle was discovered in Bavaria in 1798 by Alois Senefelder. Initially 'litho' was regarded as a fine-art medium, but from the 1820s its use gradually extended into the commercial field.

Although stone as a drawing surface was novel, the instruments used for drawing – crayon, ink, brushes, pens and etching needle – were long familiar, and for some decades lithographers were unable to break away from the styles of working associated with those media. Much early commercial litho closely imitated engraving, both metal and wood. Additionally, by first printing them on to transfer paper, actual copper, steel and wood engravings could be transferred to the printing stone, in multiples if need be. Transfer paper also freed the litho artist from having to work on the stone directly, and this encouraged lithography in the provinces, country printers being thus able to order by post everything from professionally handwritten circulars to finished designs for cards and billheads.

Engraving on stone did require the artist to work directly. The stone surface was sealed with gum-arabic solution and the design drawn through this with an etching needle. Litho ink was then applied and this, penetrating only where the needle had exposed it, put the image into the stone. Days were needed to complete even a small vignette, but work of rich tone and tiny detail could be achieved, akin to a fine etching.

By *c.*1850 lithography was becoming the premier process where elegance or decorative design was called for. Letterpress remained the process for more everyday

13

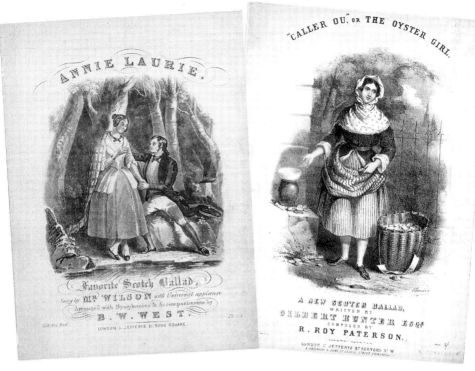

Music covers. (Left) Printed from a copper plate combining etching with aquatint, c.1840. (Right) Lithograph in crayon and ink by John Brandard, c.1860. Details enlarged 200 per cent.

work. Intaglio was in sharp decline, and its use was to survive through the century only in the limited field of business and calling cards, where engraving retained kudos, in security printing, and occasionally in the origination of designs for cheques, billheads and similar items intended for subsequent transfer to stone.

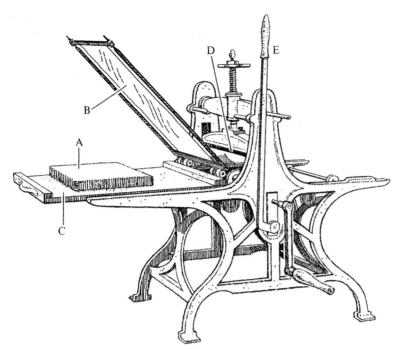

Litho hand press. Once the stone (A) had been inked, the paper laid on, and the tympan (B) lowered, the bed (C) was pushed forward beneath the scraper (D). Dropping the lever (E) lifted the bed, bringing the tympan in contact with the scraper, and the stone was then cranked through the press, pressure from the scraper effecting the impression. The lever was then raised and the bed drawn back for the sheet to be removed.

Engraving on stone: detail of a billheading of 1853 demonstrating the intricacy of design achievable by this means (shown actual size).

BOUGHT of ROBERT TOMMAS,
Maltster & Hop Merchant,
COAL & COKE DEALER.

The artistic and antique styles. (Left) Catalogue cover in the artistic manner by Parker & Hill, Birmingham; from the 'Specimen Exchange' of 1889. (Right) Almanac in the antique mode by Unwin Brothers, London, 1883, set in Caslon Old Face.

THE ART-PRINTING MOVEMENT

The first steam-powered printing machine – the term 'machine' denoting continuous action as opposed to the intermittent action of the hand press – was set up by *The Times* in 1814. After that development was rapid and newspaper machines printing twelve thousand impressions per hour were operating before the middle of the century. But such machinery was inappropriate to the needs of the jobbing printer. Endeavours to mechanise the action of the hand press resulted in *bed-and-platen* machines where the type bed reciprocated between inking rollers and a rising and descending platen. These continued in manufacture well into the second half of the century, then lost ground to *cylinder* machines based on the earlier newspaper machines, in which pressure came from a rotating cylinder. The most celebrated was David Payne's Wharfedale, which, originating in 1858 and constantly improving in design, was to continue in manufacture into the 1980s.

Powered by steam (later gas or electricity), both bed-and-platen and cylinder machines could handle large sheets of paper and thus were well suited to book printing, and in a jobbing office they were also used for posters, playbills and similar work, which tended to increase in size as the century advanced. For letterheadings,

cards and other small jobs, however, they were less appropriate, and for these the go-ahead printer was now increasingly to turn to the treadle-operated *jobbing platen*.

This machine, in which platen and type forme come together like a closing hinge, was developed by the American George Gordon. Gordon's Franklin jobber of 1856 was shown in London at the 1862 International Exhibition and then from 1867 manufactured by H. S. Cropper & Company of Nottingham as the Minerva. This, and the many similar machines which followed, in due course power-driven, were far superior to the hand press, affording the printer fine control of impression and register, making it possible to print jobs with delicacy and precision in several colours.

Much letterpress work of the 1850s and 1860s was visually undistinguished, design swamped by the ever increasing range of fancy typefaces. By the late 1860s, however, in architecture, pottery and other applied arts, adherents of the new Aesthetic movement were bringing fresh ideas into design, with 'art' as their watchword. A renascence in typography was to begin also, exploiting the opportunities now afforded by the jobbing platen.

In 1870 Oscar Harpel of Cincinnati published *Typograph, or Book of Specimens*, promoting new ideas in layout, type combination and colour. Another advocate was W. J. Kelly, of whom it was to be written 'Art printing began when William J. Kelly bent his first rule and blended his first colours in the city of New York.' To demonstrate the effectiveness of well-considered jobbing work, Kelly in 1879 began the *American Model Printer*, a thousand copies of the first number being distributed in Great Britain. Initially many British printers proved dismissive of Kelly's ideas but to others his specimens came as 'a revelation', and they were eager to learn.

In England the Cheltenham printer Thomas Hailing was already promoting similar ideas through *Hailing's Circular* and he in 1879 suggested to Andrew Tuer of the Leadenhall Press that the latter organise an ambitious self-help scheme for enlightened printers. Thus was born the *Printer's International Specimen Exchange*, the first volume of which was distributed in 1880. The idea was for each subscriber to submit prints in quantity of his best work, in due course receiving back a set of all the designs accepted. The scheme quickly caught on, the 1880s becoming a decade of great typographic enthusiasm. Compositors and pressmen, often working on hypothetical jobs on which

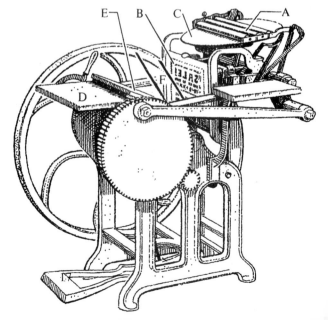

Gordon jobbing platen. Treadle-operated, the action was continuous: inking rollers (A) descended over the type forme (B), then returned to the inking disc (C). At the same time the operator took a sheet of paper from the feed board (D) and placed it on the platen (E), where small adjustable 'lays' ensured its correct positioning. Platen and forme swung together to effect printing, then opened allowing the printed sheet to be removed and the next sheet laid. Friskets (F) ensured clean separation of paper from type.

17

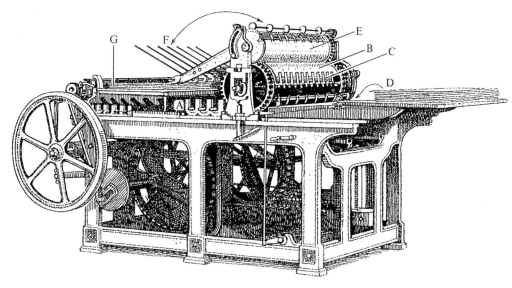

Wharfedale machine. The forme of type reciprocated between inking rollers (A) and the impression cylinder (B), which in this view would be rotating clockwise. When the cylinder grippers (C) had reached the lowest point of the cycle the cylinder momentarily halted, allowing the operator to slide a sheet of paper down the feed board (D) to be taken by the grippers. The cylinder resuming its motion, paper was brought in contact with type and thus printed, the sheet then transferring up to the delivery cylinder (E), from which flyers (F) swept it over to the delivery board (G). The reciprocation of the forme was continuous, a cut-away in the cylinder allowing it to travel up to the feed end whilst the grippers were taking the paper.

their creativity might have free rein rather than submitting more everyday work, would continue after hours, unpaid, for the accolade of seeing their designs published in the *Exchange*. And the scheme truly was international. Tuer received specimens from America, Europe and elsewhere, and similar exchanges started in Germany and France, and three in America.

Thus was the art-printing movement born, its chief characteristics being intricate composition, colour, and careful planning prior to setting, the last a significant change from earlier rule-of thumb methods.

New typefaces proliferated, and it now became customary for faces to be named whereas previously a reference number had usually been sufficient. Faces of more or less conventional form whose novelty lay largely in surface treatment continued to appear, such as *Relievo* (1887), but with novelties like *Aesthetic* (1890) even the letter shapes became unorthodox. Popular interest in things Japanese found an echo in faces like *Mikado* (1887). There were new black-letter types such as *Old Tudor Black* (1883), and strong spike-serif forms as exemplified in *Mexican* (1895).

Art printing embraced various modes of typography. In the artistic style *per se* the printed surface might, with bands of ornament or by use of printer's linear rule, be divided into panels, often with differently tinted backgrounds, the type set at angles or in curves by means of special spacing material. Also frequently used were elaborate border units, often imported from Germany. Elaborate borders were characteristic of German art printing also, but the German printers' use of type was more conventional than the British or American.

Antique or *old-style* printing also employed ornament, together with old-fashioned Roman and Victorian black-letter types, usually printed on heavy fawn or grey paper. Andrew Tuer favoured this mode, as did Unwin Brothers of Ludgate Hill, who typically advertised themselves as printing 'in Auntiente Spellynge and aftyr ye Anticke mannere'.

A boon to printers embracing these forms of layout was the American point system. Since typefounding began there had been no coordination between founders. The different sizes of type were known by a range of commonly understood terms such as *pearl, nonpareil, long primer, great primer*, etc, but these conformed to no standard: pica was nominally a sixth of an inch (4 mm), yet the pica of one founder could be significantly different from that of another. This could lead to the compositor having recourse to slips of cardboard when making up a forme to ensure the snug fit of all the disparate type material it contained.

An agreed standard was long seen as desirable but nothing was done until the typefounders Marder, Luse & Company lost everything in the Chicago fire of 1871. Re-equipping, and taking the pica of Mackellar, Smiths & Jordan as standard, the firm devised a new system based on twelve *points* to the pica, with all type and spacing precisely defined in points (the old terms instanced above becoming 5, 6, 10 and 18 points respectively). In course of time other founders in the United States and Great Britain adopted the system, the advantages proving considerable, composing time for 'the best class of ornamental work' being reduced by half.

At its most ambitious, art printing could almost rival lithography for richness in design. Litho job work, however, was itself subject to aesthetic renascence in the 1880s, finally throwing off the last hints of the intaglio processes it had supplanted. This was particularly evident in business stationery, where considerable design effort could be invested. Words and pictures were now no longer considered discrete elements but conceived as a single composition, with lettering, vignettes, panels and cast shadows creating a complex

Typefaces of the 1880s and 1890s: (from the top) Aesthetic, Milanese, Mexican, Relievo, Old Tudor Black, Mikado.

RUBENSTEIN

FLOWER GARDEN

SUBMARINE ENGINEERS

MONTHLY • MEETING

Beauties of Nature

EDINBURGH

Litho-printed billheading, 1889, engraved on stone by Harrison & Sons of Bradford. The use of panels and ribbons, the shadowed lettering and the overall illusion of depth are characteristic of the period.

Letterpress billheading in the Leicester free style, 1897. The open, carefully balanced design, using fine printing rules to structure the space, is typical, as is the use of a purely decorative stock block.

three-dimensional image far beyond the capacity of any letterpress compositor to emulate.

In 1888 publication of the *Specimen Exchange* was taken over by the newly founded *British Printer*, which, through its design suggestions, technical articles and advocacy of the point system, sought to make good work essentially a practical activity. A sister journal, the *British Lithographer*, was started in 1891, then absorbed by the *British Printer* in 1895.

In the 1890 *Specimen Exchange* the editor noted the demise of the three American exchanges and much reduction in the French. The German exchange, however, was still flourishing. He further observed that the very elaborate specimens of the 1880s were by then largely giving way to

examples of paying work, that is layouts that were artistic yet not beyond the budget of the average customer. From that trend towards a more rational typography evolved the *Leicester free style*, largely through the influence of Robert Grayson, works manager of Raithby, Lawrence & Company of Leicester, publishers of the *British Printer*. Chief characteristics of the style were carefully balanced, asymmetrical layout and considered use of space. Indeed 'white space' – non-printed areas within the design – largely took the place of the elaborately contrived ornamentation of the 1880s, much use being made of printing rule for these effects.

Between the various styles of the art-printing movement there were hybrid variations, and the artistic mode *per se* still

20

had its adherents in the 1890s; but highly elaborate design had gone as far as it could go in the 1880s and inevitably thereafter the trend was towards simplicity.

In 1891, reacting against the low standards in commercial book production, the designer-craftsman William Morris founded the Kelmscott Press. Elaborately decorative, the books that Morris was to print had no direct influence on the trade; but Morris's types were a different matter. Based on typefaces from the earliest days of printing, they were strong and beautiful in form and, inspired by them, younger printers began to develop a new, purer style of typography in which the type itself – of good design, well set, the point sizes carefully chosen – became the aesthetic focus. The trend was first apparent in American work, designer-printers such as Daniel Updike, Will Bradley and others espousing what came to be dubbed 'the severe American style', working largely with types closely based on Morris's own. Equally favoured was the classic Roman designed in the 1720s by the English founder William Caslon, which, revived in 1857 as *Caslon Old Face*, had already been popularised in England by adherents of the antique mode.

The art-printing movement faded with the 1890s. Contributions to the *Specimen Exchange* became fewer, those for 1894 and 1895 being distributed in a single volume. The next, volume XVI, did not appear until 1898, after which there were no others. With the new century, plain well-considered typography gradually took over in the leading American and British composing rooms. But a fundamental change in attitude brought about by art printing continued, for it was during the artistic period that many in the trade had seen the value of considered design, the drawing of a layout on paper before ever a piece of type was set, and in this we see the advent of the typographer in the modern sense of someone who is the planner of print rather than its compositor.

Billheading, 1913, by the typographer Arthur Nelson of the Oswald Printing Company, New York. Set throughout in Caslon Old Face in the 'severe American style', the design achieves quality through judicious choice of type sizes, style variants and spacing.

Home Office: Kansas City, Mo. Branch Offices: Shreveport, La.; Claramore, Okla.; Gifford, Ark.

Our Motto: GOOD DIRT AT LOW PRICES AND ON EASY TERMS

J. P. Allen **Allen & Hart** B. L. Hart

DEALERS IN FARM LANDS

of Oklahoma, Arkansas and Louisiana

1018-1019 Commercial National Bank Building
Shreveport, La.

We have bought and sold $2,000,000 worth of land in the southwest and located one thousand families who have made good.

We offer cheaper homes in a milder climate. We sell our own lands.

[]

American trade card
c.1880 promoting the
patent medicine Ayer's
Cherry Pectoral, printed
in eight colours from
engraved wood blocks.

CHROMOLITHO TO PROCESS

The majority of pictorial printing in the first decades of the nineteenth century was monochrome. The need for colour was long felt. Hand colouring provided an answer for a time but this became increasingly impractical as demand for print continued to rise.

In 1822 William Savage demonstrated how pictures could be built up by overprinting wood-engraved blocks inked in different colours, but this process had no immediate adherents. Charles Knight's *illuminated printing*, patented in 1838, featured a detailed wood-engraved image and overprinting with flat colours from metal blocks. This, however, depended on a special press which enabled each colour to be printed whilst the preceding inks remained wet, and though Knight used it in his own publications, notably the part work *Old England* (1844-5), it was taken no further.

Commercially more successful was George Baxter's process patented in 1835 which required only conventional equipment. Baxter commenced with an intaglio-printed key image, then overprinted from a series of wood blocks, which, unlike Knight's metal blocks, were finely engraved to create more subtly graded colour effects. Baxter prints were expensive and mainly used for book illustrations or as prints in their own right, with some applications on music covers and fancy needle packets.

In the 1850s it was realised that the key image itself could be a wood engraving – a reversion to Savage's idea – and thereafter colour printing was increasingly done from the wood alone. The number of blocks was reduced also. Baxter printed in from eight to twelve workings, sometimes many more, but firms such as Leighton Brothers could when necessary print acceptable illustrations from as few as six.

These letterpress developments were paralleled in lithography. In *tinted* litho two stones were used, one printing the black key drawing, the other fawn, which, with the white of the paper left for highlights, created a three-colour effect. In the 1830s a pale blue was often added and by the 1840s *chromolithography*, litho printing in several colours, had developed from this.

Steam-powered litho cylinder machines were introduced in the 1850s, becoming common by the late 1870s. Machine printing required stones with polished surfaces,

22

thus precluding crayon drawing, which required grained stone. Denied the crayon's tonal qualities, litho artists developed *pen stippling*, building up their tones with minute dots and ticks, thereby discovering a means whereby colour overprinting of great subtlety could be achieved.

Chromo work started with an original design in oils or watercolour from which the master lithographer would draw the *key stone*, virtually a 'painting-by-numbers' guide, with each outline corresponding to a colour difference, perhaps very slight, on the original. This plan was then transferred as a non-printing image on to as many *proving stones* as were needed, a team of artists then stippling in just the areas appropriate to the printing colour of each. The skill was considerable, first of the master in analysing by eye alone the colour content of the original, and then of his team in ensuring that their separate stones would, when overprinted, recreate the original in all its subtlety. The number of colours usual for a Christmas card was ten, but double this or more could be employed where very close fidelity was called for, as in fine-art reproductions.

For printing, the images were transferred on to large *machine stones*. Small-scale work such as greetings cards and valentines was transferred in multiples, and thus large orders could be printed with economies in both time and cost. Letterpress could not compete with this and though colour printing from wood was to continue into the 1880s it was largely for children's books, with only minor uses in the jobbing field. The

Chromolitho music covers: (left) by Alfred Concanen, c.1870; (right) by H. G. Banks, Concanen's successor as premier illustrator of the comic song, 1893.

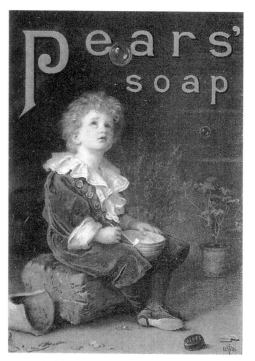

efflorescence of colour in the printed ephemera of the later Victorian period was firmly based on chromolithography.

In the last three decades of the century the pace of advertising quickened with the rise of branded goods – tea, cocoa, beef extract, soap and other essentials ready packaged under brand names that were to become household words. Among new forms of advertising was the pictorial trade card, which, unlike the similarly named *tradesman's* or business card, was designed as a novelty to be collected. Visual appeal was all important, subjects chosen often having little bearing on the goods promoted and popular images being overprinted with advertising for quite different products. Trade cards were produced on both sides of the Atlantic though to a greater extent in the United States than Great Britain.

Posters printed from large wood blocks had been seen occasionally from the 1840s onwards but it was chromolitho that was to turn the streets into 'the poor man's picture gallery'. In 1887 T. J. Barratt, the enterprising proprietor of Pears' Soap, purchased Sir John Millais's painting 'Bubbles'. The picture, featuring the artist's little grandson, had been much admired when exhibited in 1886, and gallery-going society was shocked when Barratt reproduced it with the addition of

'Bubbles' by Sir John Millais, as adapted in 1887 to advertise Pears' Soap.

Below: *Machine stone ready for the printing of chromolitho Christmas cards, 1890, the images transferred in multiples. As printing was in ten colours, another nine stones of this size would be needed.*

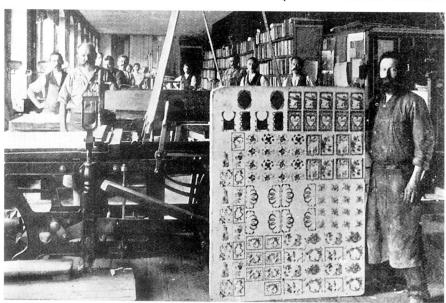

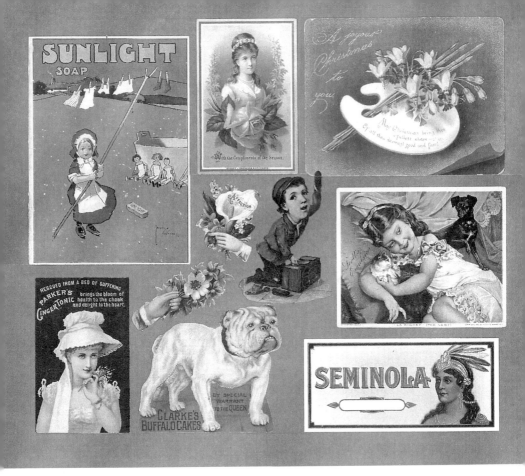

Chromolithography. (Top) Magazine inset by Lawson Wood, 1910; Christmas calendar card promoting Li-Quor Tea Company, 1880; Christmas card. (Centre) Scraps; American trade card for Scott's Emulsion. (Bottom) American trade card for Parker's Ginger Tonic; British card for Clarke's Buffalo Cakes for Dogs; cigar-box label.

'Pears' Soap' boldly lettered above the boy's head, thus converting it into a poster. Barratt, however, owning the copyright, could do as he wished. There were to be similar adaptations with other artists' work. Thus at this period the poster was conceived as the trade card writ large – an attractive picture with an advertising message added.

Much work was done in the form of *stock posters*, colourful imagery picturing fairs, races, popular melodramas, etc, which could be made specific to particular events by inexpensive letterpress additions. Low-budget events could thus enjoy pictorial advertising at modest outlay, origination costs being spread over large print runs. One firm, David Allen & Sons, had no fewer than seven hundred stock designs in their catalogue by 1900.

From France in the late 1880s came the innovation of the originating artist working directly on the stone himself without the intervention of litho artists. This brought a new awareness of line, shape and colour into poster design throughout

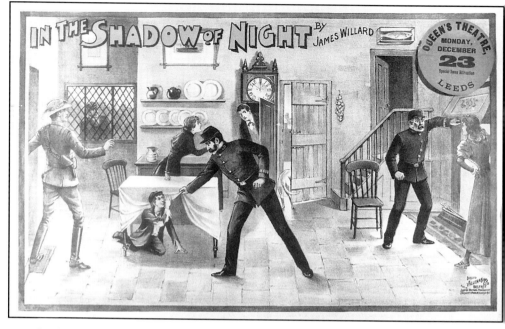

Stock poster for a melodrama, chromolitho in five colours by David Allen & Sons, c.1900. Date and venue have been added with a letterpress sticker.

Europe and America, and with it recognition of advertising as a legitimate field for painters and illustrators.

Increasing literacy made the popular magazine a significant advertising medium also. Magazines, however, were printed letterpress and in black only. The need for colour was answered by chromolitho *insets* – virtually miniature posters, separately printed then inserted during binding. Insets provide a conspectus of the graphic styles of the period, from the interpretative stipplings of litho artists to the lively imagery of illustrators like John Hassall, Will Owen and Lawson Wood who drew for the stone directly.

A field where the artist always had drawn directly on to the stone was the pictorial music cover. Music was not usually published in editions large enough to warrant machine printing, and if power was applied it was to large conventional presses where it eased the sheer labour of cranking the stone through. Thus use of grained stone continued and a simpler form of chromolitho developed, the design largely carried by a black key drawing on to which colour was overprinted. Several minor artists were particularly associated with music covers, among them John Brandard, who specialised in ballad and operetta, his covers often featuring idealised young ladies, and the Irishman Alfred Concanen, leading illustrator of the comic song. When Concanen died in 1886 that role was taken by Henry Banks, who, working in the fashionable artistic mode, would characteristically combine several vignettes and a portrait of the artiste in a single design.

A means of printing photographic images was finally realised in the early 1880s with various forms of *halftone screen*. These enabled a photograph to be rephotographed on to copper as a pattern of dots, the dots varying in size according to the tones of the original. Etching away the exposed copper between the dots left a relief image suitable for letterpress printing. Without need for a screen, a zinc *line block* could similarly be made from an artist's ink drawing. Collectively these

methods were known as *process*. Early halftones lacked contrast and for some years wood engravers were employed in enhancing the etched copper image with their burins; but it was a short reprieve and by the end of the century the days of the wood engraver were over.

Before 1890 Frederick Ives of Philadelphia had adapted the halftone screen to colour reproduction. Three halftones were made, the successive exposures through the screen being via violet, green and red filters, the dot sizes varying according to the colour content of the original. When the halftones were overprinted in yellow, red and blue respectively the juxtaposed dots recreated the effect of continuous colour. Three-colour work could lack depth of tone, but when needed this could be improved with a fourth printing in black.

Monochrome *photolithography*, the adaptation of process to litho printing, was well established before 1900; and four-colour was initiated in 1909-10, though it was to be many years before chromolitho was completely superseded. Since 1877 the litho *offset* principle had been in commercial use for tin printing and in 1904 the American Ira Rubel adapted it to printing on paper. It had long been known that lithography could be achieved with materials other than stone and Rubel's press printed from a flexible aluminium plate locked on to a cylinder. Printing was via an intermediary cylinder sleeved with rubber, the impression 'offsetting' from plate to rubber to paper. The advantage over direct printing was that this enabled fine-screen halftones to be printed on to non-glazed papers.

Thus by the early 1900s, in little more than a century, printing had changed from a craft-based activity into an industry that was as much the province of the chemist and engineer as it was that of the printer. In 1893 Willis Gamble and the pharmaceutical chemist A. W. Penrose went into partnership supplying the process-engraving trade. In 1895 they began publication of the annual *Process Work Year Book*, which was to become virtually the specimen exchange of process work, and by 1898 they had extended its remit to embrace articles on all aspects of printing and design. As *Penrose's Annual* it continues today and it is there that the ongoing story of printing is to be found.

Letterheading, 1908, printed letterpress with the photograph reproduced by the halftone process.

COLLECTING EPHEMERA

Virtually all jobbing printing was ephemeral. Once the coach journey was over, the performance had ended and the tradesman's bill had been paid, then the coach ticket, the playbill and the elegantly headed account were little more than waste paper. Even so, much has survived for today's collector.

Music covers, greetings cards, early newspapers and other ephemera may be found at antiques and collectors' markets, where there may also be stock blocks to be discovered, engraved copper plates and Victorian wood type. Book fairs are another source, and even fairs devoted to cigarette cards, stamps and coins have turned up trade cards and billheads. It is worth enquiring also at second-hand bookshops, for generations of readers have used handbills, tickets and other trivia as bookmarkers. The best sources of all are antique-paper fairs, particularly the bazaars run by the Ephemera Society, where one can browse through the stocks of dealers both professional and part-time and find on friendly offer anything from a seventeenth-century newspaper to an album of Victorian chromolitho.

One may also seek ephemera at source, alert for long-established businesses where old invoices and advertising may yet remain in attic or cellar. Gaining access to such material requires tact, but this can be one of the most rewarding ways of adding to one's collection. It was the chance sighting of current posters printed in old-fashioned type that led Maurice Rickards and Elizabeth Greig of the Ephemera Society to a cornucopia of ephemera and printing history, though in this case the find proved so important it was deemed best that it remain *in situ*. Thus it was that Robert Smail's Printing Works, Innerleithen, Peeblesshire, came to be reopened as a working museum of printing by the National Trust for Scotland.

Interesting ephemera need not be rejected simply because it is dirty or damaged. Surface dirt can be removed with a draft-cleaning pad or art-gum eraser, both superior to either india-rubber or plastic eraser for document work. Other techniques include washing, usually followed by resizing to restore crispness to the paper, and bleaching where paper is badly discoloured. Easily learnt, these procedures are described in guides such as Maurice Rickards's *Collecting Printed Ephemera* and Graham Moss's *Collector's Guide to the Care and Repair of Books and Documents*.

Plastic-leaved albums for housing all forms of printed paper are widely available, leaves being made in a variety of pocket arrangements to suit different formats. The cheaper plastics, however, contain a polymer plasticiser which gives flexibility but can in time chemically migrate into any paper it is in contact with, with deleterious results. The plastic known either as Melinex or Mylar is chemically inert and much to be preferred. A reliable dealer will know which plastics have been used in his or her albums.

Collectors opting for a paper-leaved album can utilise the familiar ring-binder, preferably one with covers wide enough to take A4 document pockets. The extra width allows a wider sheet to be used, true A4 being a little narrow for an album page. Paper may be obtained from art shops or printers, where it may be possible to have the sheets guillotined to size. Narrow reinforcing strips can be cut from the trimmings and fixed to the inner edges of the sheets with double-sided tape to reduce wear when the leaves are turned. Paper should be non-acidic, with a substance around 150 gsm. A dark colour will show the collection off best.

Ephemera may be mounted on to album pages with archival repair tape, using slips of tape either like stamp hinges or formed into loops for use in a similar way to double-sided tape. Ordinary sticky tapes should never be used as they would cause damage.

An alternative to the album is the

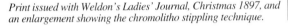

Print issued with Weldon's Ladies' Journal, Christmas 1897, and an enlargement showing the chromolitho stippling technique.

solander box. This is dustproof, made of plywood or board, and in it one houses the collection mounted on a series of separate cards.

Growing interest in things historical has led to the reproduction of much early graphic material. Though not published to deceive, such items can, when purposely distressed, take in the unwary. Every illustration in this book is, naturally, a reproduction, and the cover is printed in four-colour halftone. Examination with a magnifying glass will reveal the yellow, red, blue and black dots by which all the subtly graded colours of the original photograph have been reproduced. Colour printing purporting to be earlier than *c.*1890 which shows this regular pattern should be treated with great suspicion. The picture above shows what genuine chromolitho will look like. On a 'repro' this texture will be overlaid with tell-tale halftone dots – as indeed it must be here, though the enlargement should be sufficiently clear for the point to be made. In the later days of chromolitho *Ben Day tints* enabled artists to cut out much tedious stippling by printing ready-made textures on to the stone, and these also can be dot patterns, but they lack the regularity of halftone.

Photolitho reproductions of old letter-press notices and playbills may deceive when creased or grubby. One should look for a slight darkening around the boundaries of letters caused by ink squeezing to the edges of the type at the moment of printing. This will be absent on the repro.

Ephemera and its means of production are an extensive study and only so much can be imparted by word and picture. Much else is to be learnt by seeing original material and meeting like-minded enthusiasts. Here the Ephemera Society is of great value, its membership including libraries, museums and private collectors. Articles on all aspects of printed and handwritten ephemera are published in the society's journal, *The Ephemerist*, together with reviews of exhibitions and books and notices of coming events. A varied programme of lectures and visits is organised and bazaars promote the discovery of fresh collectable material. Here one meets fellow enthusiasts who value ephemera for its social-history content, others who focus on the ephemera of a particular trade or profession, and those to whom these transient documents are the tangible history of printing itself.

FURTHER READING AND ORGANISATIONS

BOOKS

Cirker, C. (editor). *1800 Woodcuts by Thomas Bewick and His School*. Dover, New York, 1962.

Dyson, A. *Pictures to Print*. Farrand Press, 1984. Victorian pictorial engraving.

Gascoigne, B. *How to Identify Prints*. Thames & Hudson, 1986.

Glaister, Geoffrey Ashall. *Glaister's Glossary of the Book*. Allen & Unwin, revised edition 1979.

Gray, N., and Nash, R. *Nineteenth-Century Ornamented Typefaces*. University of California Press, 1976.

Howe, E. (editor). *The Working Man's Way in the World*. Printing Historical Society, 1967. Autobiography of printer Charles Manby Smith.

Lewis, J. *Printed Ephemera*. Antique Collectors' Club, 1990.

Moran, J. *Printing Presses*. Faber & Faber, 1973.

Moss, G. *Collector's Guide to the Care and Repair of Books and Documents*. Papersafe, 11A Printer Street, Oldham OL1 1PN, 1992.

Rickards, M. *Collecting Printed Ephemera*. Phaidon, Christies, 1988.

Steinberg, S.H. *Five Hundred Years of Printing*. Penguin, 1955.

Turner, E.S. *The Shocking History of Advertising*. Penguin, 1952.

Twyman, M. *Printing 1770-1970*. Eyre & Spottiswoode, 1970.

Weber, W.A. *History of Lithography*. Thames & Hudson, 1966.

Weekley, M. (editor). *A Memoir of Thomas Bewick*. Cresset Press, 1961.

Weill, A. *The Poster*. Sotheby's Publications, 1985.

ORGANISATIONS

Ephemera Society, 8 Galveston Road, Putney, London SW15 2SA.

National Printing Heritage Trust. Enquiries to: Dr Derek Nuttall, Langdale, Pulford Lane, Dodleston, Chester CH4 9NN (stamped addressed envelope appreciated).

Printing Historical Society, St Bride Institute, Bride Lane, Fleet Street, London EC4Y 8EE.

PLACES TO VISIT

Antique printing presses and items of printing equipment are not uncommon in museum collections and therefore this list is limited to places where there is a holding of some significance. 'Equipment' denotes anything from composing sticks, engraving tools, type etc to large guillotines. 'Ephemera' indicates that a significant amount of material is displayed. As with all collections, displays may change from time to time, so a telephone call is advisable before travelling any distance.

Amberley Museum, Houghton Bridge, Amberley, Arundel, West Sussex BN18 9LT. Telephone: 01798 831370. Columbian and platen presses; composing machines and other equipment; demonstrations.

Beamish, The North of England Open Air Museum, Beamish, County Durham DH9 0RG. Telephone: 01207 231811. Important collection of presses and equipment; demonstrations in reconstructed print shop; ephemera.

Beck Isle Museum of Rural Life, Bridge Street, Pickering, North Yorkshire YO18 8DU. Telephone: 01751 473653. Columbian and platen presses; equipment; ephemera.

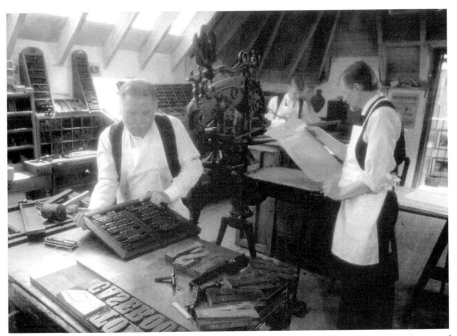

Robert Smail's Printing Works, Innerleithen, Peeblesshire. A compositor lifts a forme of type which he has just locked up whilst the pressman checks a proof pulled on the Columbian hand press behind. After its historical significance was realised the works was opened by the National Trust for Scotland in 1990 as a working museum of printing.

Bewick Studios, Mickley Square, Mickley, Stocksfield, Northumberland NE43 7BL. Telephone: 01661 844055. Rolling presses, Albion and platens; equipment; demonstrations. Appointment advisable. Relocation in Newcastle upon Tyne as a major presentation of printing in the north-east is planned.

Birmingham Museum of Science and Industry, Newhall Street, Birmingham B3 1RZ. Telephone: 0121-235 1661. Stanhope and other hand presses; composing machines. Appointment advisable.

Blake's Lock Museum, Gasworks Road, Reading, Berkshire RG1 3DH. Telephone: 01734 390918. Britannia iron press and other equipment in reconstructed print shop.

Blists Hill Open Air Museum, Legges Way, Madeley, Telford, Shropshire. Telephone: 01952 586063 or 583003. Columbian, platens and other equipment in reconstructed print shop.

Bradford Industrial Museum, Moorside Road, Eccleshill, Bradford, West Yorkshire BD2 3HP. Telephone: 01274 631756. Platen and cylinder machines and other equipment at present in store.

Bridewell Museum of Norwich Trades and Industries, Bridewell Alley, Norwich, Norfolk NR2 1AQ. Telephone: 01603 667228. Hand and platen presses; equipment; ephemera.

Bristol Industrial Museum, Princes Wharf, Prince Street, Bristol BS1 4RN. Telephone: 0117-925 1470. 1843 Columbian; twentieth-century presses and equipment.

Hartlepool Historic Quay, Maritime Avenue, Hartlepool, County Durham TS24 0XZ. Telephone: 01429 860077. Reconstructed quayside includes print shop *c*.1800 with replica wooden press.

Hot Metal Press, Elsecar Heritage Centre, 5 Ironworks Row, Wath Road, Elsecar, Barnsley, South Yorkshire S74 8HJ. Telephone: 01226 740498. Columbian, platens and cylinder machines; composing machines; demonstrations.

John Jarrold Printing Museum, Whitefriars, Norwich, Norfolk NR3 1SH. Telephone: 01603 660211 extension 304. Important collection of hand, platen and cylinder presses; litho presses; composing machines; equipment. Appointment necessary.

Leeds Industrial Museum, Armley Mills, Canal Road, Armley, Leeds LS12 2QF. Telephone: 0113-263 7861. Eighteenth-century wooden press and several iron presses; equipment.

Maidstone Museum and Art Gallery, St Faith's Street, Maidstone, Kent ME14 1LH. Telephone: 01622 754497. Important collection of Baxter prints.

Museum of Lakeland Life and Industry, Abbot Hall, Kendal, Cumbria LA9 5AL. Telephone: 01539 722464. Columbian press.

Museum of Science and Industry in Manchester, Liverpool Road, Castlefield, Manchester M3 4JP. Telephone: 0161-832 2244. Columbian and two platens; demonstrations. Important collection of presses and early composing machines due for display in 1998.

Nottingham Industrial Museum, Courtyard Buildings, Wollaton Park, Nottingham NG8 2AE. Telephone: 0115-928 4602. Albion and platen; equipment.

Otley Museum, Civic Centre, Cross Green, Otley, West Yorkshire LS21 1HD. Telephone: 01943 461052. Wharfedale; archive relating to local Wharfedale manufacture.

The Printing House, 102 Main Street, Cockermouth, Cumbria CA13 9LX. Telephone: 01900 824984. Important collection of presses including rare 1820 Cogger; composing machines; ephemera; demonstrations.

Prittlewell Priory, Priory Park, Victoria Avenue, Southend-on-Sea, Essex SS2 6EW. Telephone: 01702 342878. The presses, guillotine, wooden and lead type of A. J. Paget & Son, jobbing printers at Leigh-on-Sea, which closed in the 1940s; also a display of printed material from 1540 to the nineteenth century.

Robert Smail's Printing Works (National Trust for Scotland), Innerleithen, Peeblesshire EH44 6HA. Telephone: 01896 830206. Columbian, platen and Wharfedale; type, litho stones, etc; demonstrations; important archive of ephemera.

St Bride Printing Library, St Bride Institute, Bride Lane, Fleet Street, London EC4Y 8EE. Telephone: 0171-353 4660. Reference library covering all aspects of the trade. Some presses and other equipment may be viewed by appointment.

Salford Museum and Art Gallery, Peel Park, The Crescent, Salford, Lancashire M5 4WU. Telephone: 0161-736 2649. Columbian and Albion in reconstructed print shop; equipment.

Science Museum, Exhibition Road, South Kensington, London SW7 2DD. Telephone: 0171-938 8000. Important collection of presses including *c*.1700 wooden press in reconstructed print shop; composing machines; equipment.

Thomas Bewick Birthplace Museum (National Trust), Cherryburn, Station Bank, Mickley, Stocksfield, Northumberland NE43 7BL. Telephone: 01661 843276. Rolling presses and Albion; wood blocks, copper plates, etc; demonstrations.

Watford Museum, 194 High Street, Watford, Hertfordshire WD1 2HG. Telephone: 01923 232297. Stanhope and other hand presses; platen; equipment.

William Clowes Print Museum, Newgate, Beccles, Suffolk NR34 9QE. Telephone: 01502 712884. Hand and platen presses; equipment.

York Castle Museum, Tower Street, York YO1 1RY. Telephone: 01904 653611. Reconstructed print and engraving shops; Stanhope, Columbian and rare counterweight Albion; equipment.